SEP 1 3 1999

How Artists See
THE WEATHER
Sun Wind Snow Rain

Colleen Carroll

ABBEVILLE KIDS

A DIVISION OF ABBEVILLE PUBLISHING GROUP

New York London Paris

*"Painters understand nature and love her
and teach us to see her."*

—VINCENT VAN GOGH

———————

This book is dedicated with thanks and love
to my husband, Mitch Semel.

I'd also like to thank the many people who helped make
this book happen, especially Jackie Decter, Ed Decter,
Colleen Mohyde, Avice O'Neil, and Enid Stubin.

—COLLEEN CARROLL

JACKET AND COVER FRONT: Vincent van Gogh, *The Sower,* 1888 (see also page 4).
JACKET AND COVER BACK, LEFT: Vasily Kandinsky, *Landscape with Rain* (detail), 1913 (see also pages 34 and 35); RIGHT: Edouard Manet, *Departure from Boulogne Harbor* (detail), 1864–65 (see also pages 18 and 19).
JACKET BACK, BOTTOM: Paul Signac, *Boulevard de Clichy,* 1886 (see also pages 22 and 23).

EDITOR: Jacqueline Decter
DESIGNER: Patricia Fabricant
PRODUCTION EDITOR: Abigail Asher
PRODUCTION MANAGER: Lou Bilka

Abbeville Publishing Group, 22 Cortlandt Street, New York, N.Y. 10007. The text of this book was set in Stempel Schneidler. Printed and bound in Hong Kong.

First library edition
10 9 8 7 6 5 4 3 2 1

Library of Congress Cataloging-in-Publication Data
Carroll, Colleen.
 The weather : sun, wind, snow, rain /
Colleen Carroll.
 p. cm. — (How artists see,
 ISSN 1083-821X)
 Includes bibliographical references.
 Summary: Examines how various elements of the weather have been depicted in works of art from different time periods and places.
 ISBN 0-7892-0031-7; 0-7892-0478-9 (library edition)
 1. Weather in art—Juvenile literature.
[1. Weather in art. 2. Art appreciation.]
I. Title. II. Series: Carroll, Colleen.
How artists see.
N8261.W42C37 1996
760'.1—dc20 95-25797

CONTENTS

THE SOWER

by Vincent van Gogh

Everything on Earth is affected by the weather. And
because weather by its very nature changes from day to
day, people have a great interest in it and what it will do.
Artists, in particular, have always been fascinated by the
weather and have tried to capture its effects in their
work. As you read on, you'll discover many of the ways
that artists see the weather.

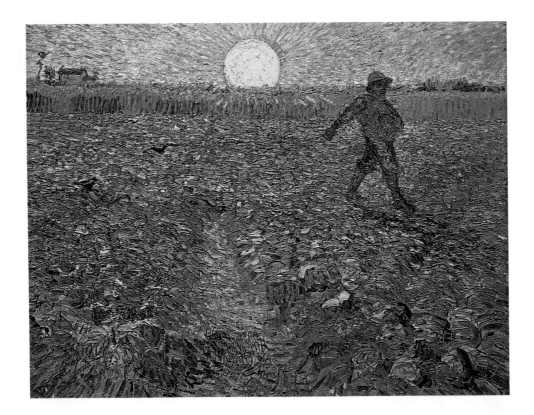

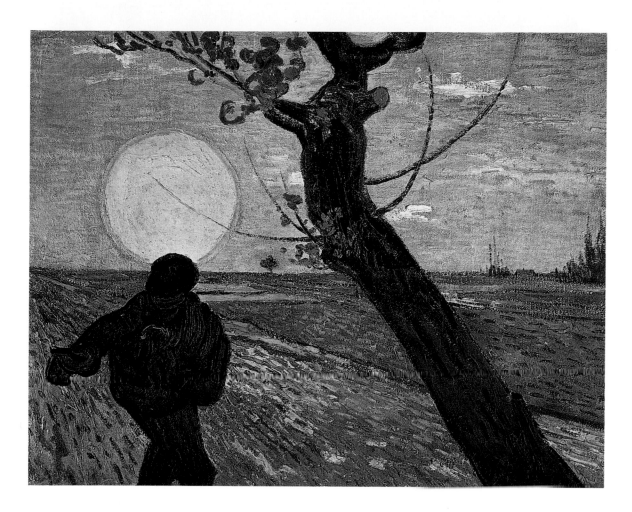

This artist made many pictures of sunny days. The paintings on these two pages show farmers sowing seeds in a field. Both have a big, bright sun in the background. The paintings are of the same subject, and even have the same title, yet they don't look the same. In what ways are they different? Which picture shows a sunrise? In which picture is the sun setting? How can you tell?

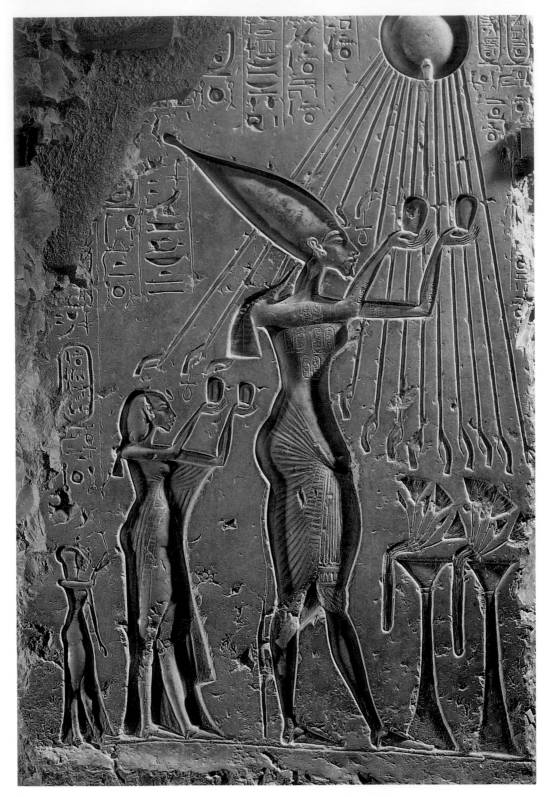

6

AN EGYPTIAN ROYAL FAMILY OFFERS A SACRIFICE TO ATEN, THE SUN GOD

Artist Unknown

The people in this sculpture were rulers of an ancient Egyptian civilization. To them, the sun was a god. To show its importance, the artist carved its disk very deeply, so that it would stand out more than any other part of the sculpture.

Members of the royal family stand in the sun's light and offer it gifts of thanks. Trace your finger along the rays of sunlight. You may have noticed the tiny hands at the end of each ray. What do you think these hands are doing?

SUN DRAWING WATER

by Arthur Dove

Where is the sun in this painting? Is it hiding? Instead of painting the sun as a big, fiery ball, the artist decided to show its rays, or beams of light. The rays break through the clouds and spread their light across the sky. Trace your finger along the ribbons of sunshine.

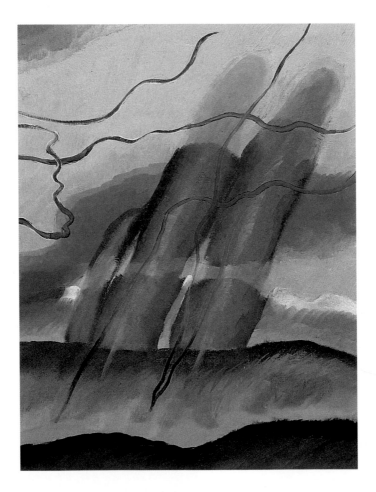

8

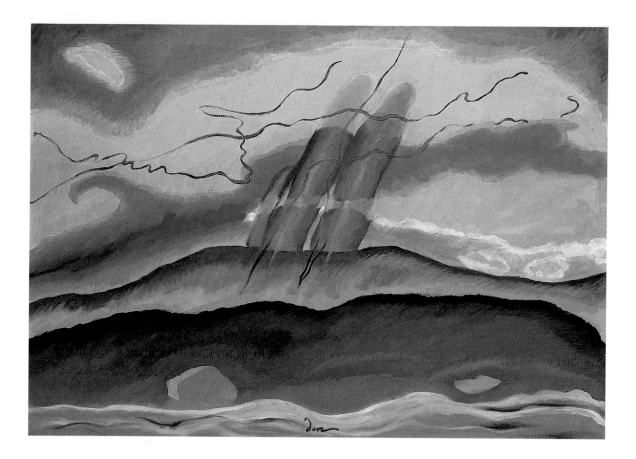

The sun's heat "draws" water by pulling it from the land back into the air, where it forms clouds. To better understand what the artist was trying to capture in the picture, think about what happens to puddles after a rainstorm. Where do they go?

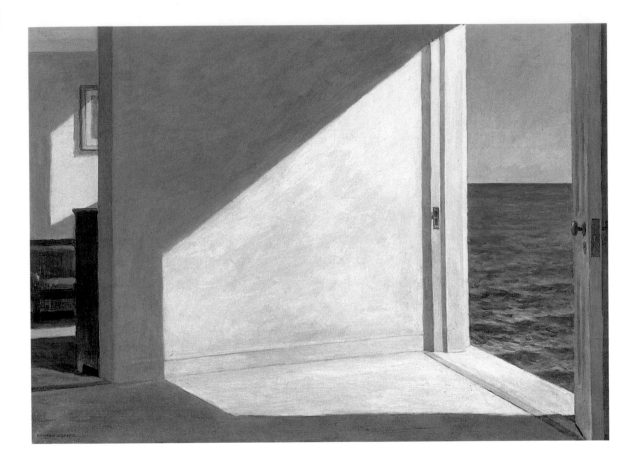

ROOMS BY THE SEA

by Edward Hopper

This artist created sunlight without even putting the sun in the picture. Trace your finger around the patch of sunshine that comes through the open door and settles on the empty wall. Where else do you see the sunlight?

The color of sunlight doesn't stay the same, but changes over the course of the day. The light pouring through the doorway is a pale shade of yellow. Does it look like the sunlight that sneaks into your room to wake you up in the morning? Maybe it's the warm yellow light of afternoon. What time of day do you think it is?

WIND FROM THE SEA

by Andrew Wyeth

If the wind is invisible, how can you tell it's blowing? When artists paint pictures of windy days, they must think about how the wind reveals itself. How do you know the wind is blowing in this painting? Do you think it's a strong gust or a gentle breeze?

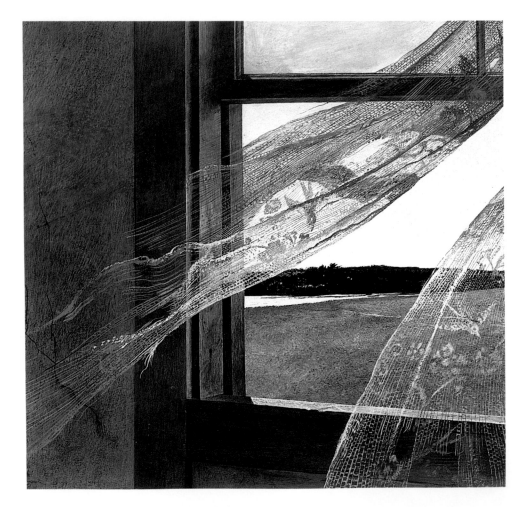

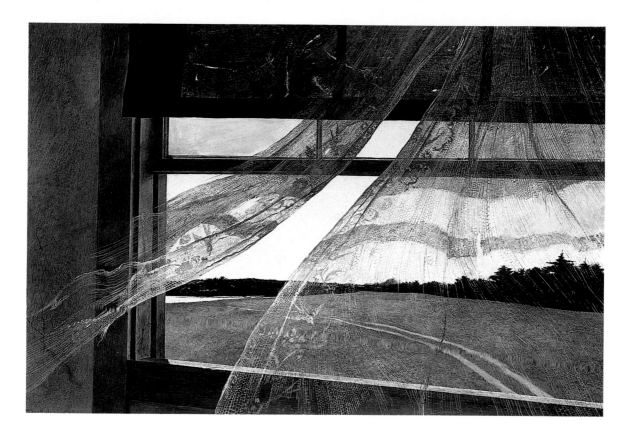

Close your eyes for a moment and imagine yourself
inside this room. Does the wind feel cool and soothing
on your face, or does it blow hot and dry? What does it
sound like as it blows into the room? Pretend you are
these billowing lace curtains and move as they do on
this summer wind.

THE WEST WIND

by Winslow Homer

In this painting you see the wind in a different way. The artist painted the grass on the hillside with long, soft strokes to help you imagine the wind blowing through it. Move your finger over the grass that leans against the slope. What else do you see that tells you the wind is blowing?

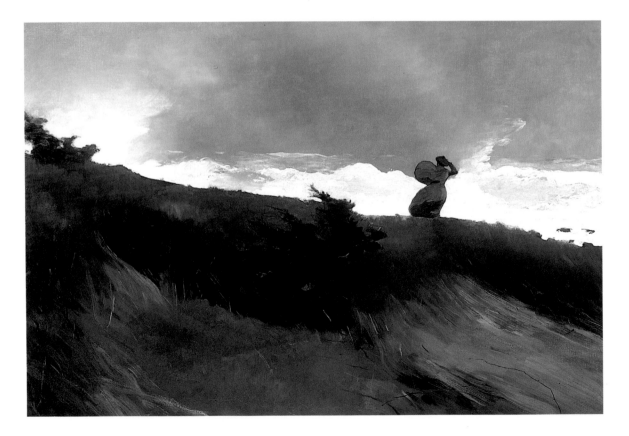

14

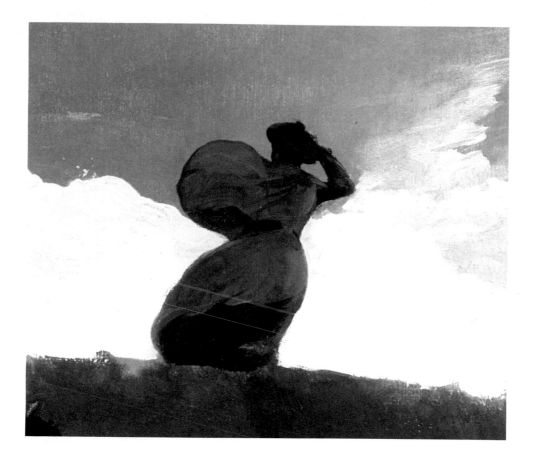

The lady walking along the top of the hill seems to be looking off into the distance. Perhaps she has noticed the dark cloud that hangs overhead. What do the colors of the sky and the hillside tell you about the weather? Sometimes the wind will "kick up" before a storm. Do you think this lady will get caught in the rain?

A GUST OF WIND AT EJIRI

by Katsushika Hokusai

Here's another scene of travelers on a windy day. In this picture, people huddle against the wind's powerful force and struggle to hold on to their belongings. Do you think they're in danger? The wind is strong enough to pull the leaves off the trees and send objects flying. Point to the woman whose papers are being scattered by the blowing air. Do you think she'll ever get them back? Where do you think they'll finally land?

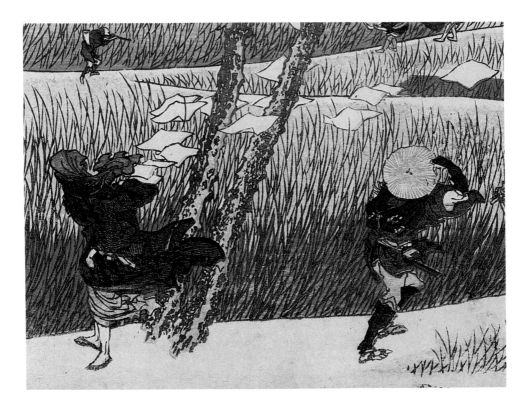

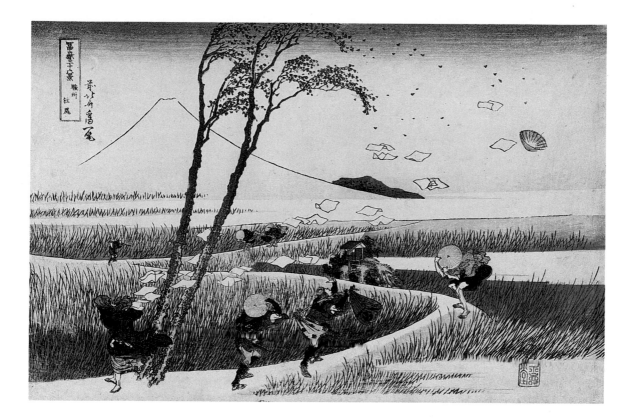

This picture is full of movement and energy, just like the wind. By showing how the people react to the wind, the artist helps us imagine how hard it is blowing. Look back at *The West Wind*. In which picture do you think the wind is stronger?

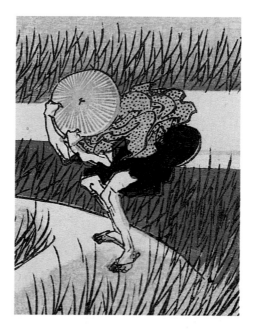

DEPARTURE FROM BOULOGNE HARBOR

by Edouard Manet

Sometimes the wind can create shapes, such as when it's filling the sails of a sailboat. How does the wind give shape to the boats in this picture? You may have noticed that the artist made the sails with curving lines. These lines help you "see" the wind as it pushes against the cloth. Trace your finger around the outlines of the sails. If the wind were to die down, how would the shapes change?

18

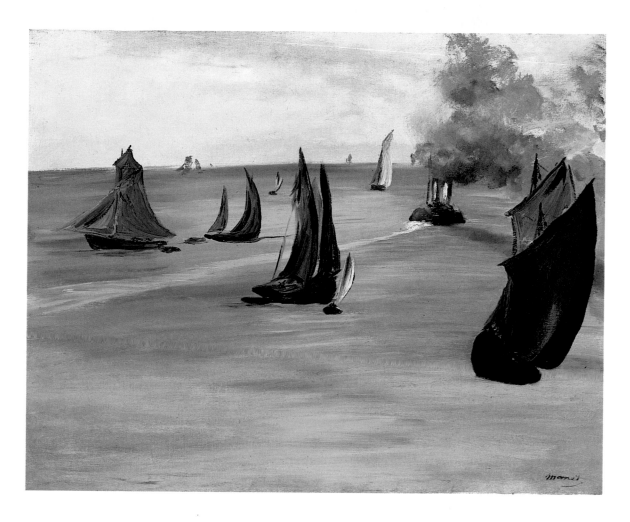

Imagine yourself sailing on one of these boats. How quickly do you think the wind would move you over the water? If these boats were in a race, which one do you think would win?

SNOWSTORM—STEAMBOAT OFF A HARBOR'S MOUTH

by James Mallord William Turner

This artist made many paintings that show the powerful, sometimes frightening force of weather. In this picture, he tried to capture a boat caught in a swirling blizzard. Circle your finger quickly around the boat to sense the commotion of the snow and wind. Have you ever been caught in such a raging snowstorm?

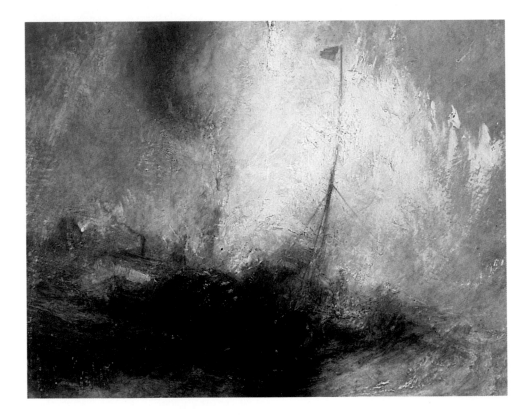

20

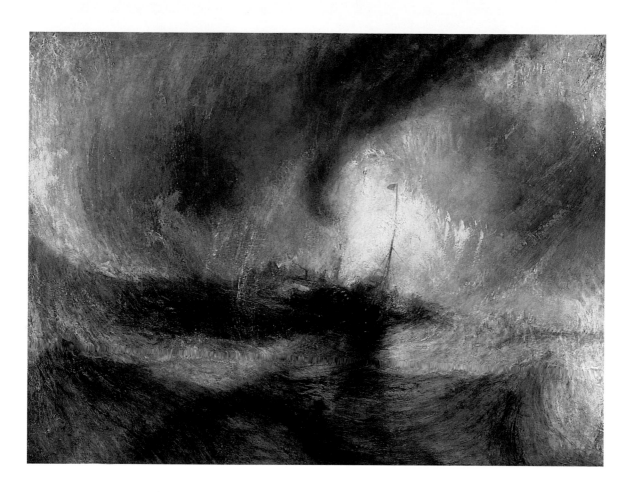

It's been said that the artist tied himself to the mast of a boat like this one to experience the fury and motion of a snowstorm at sea. Expressing feelings in a painting can be very hard to do. How does this picture make you feel? Would you want to be on a boat during such a blizzard?

BOULEVARD DE CLICHY, PARIS

by Paul Signac

This picture shows a street in a French city during a snow flurry. The artist painted the snowflakes in a very unique way. If you look closely, you will see that the entire picture is made up of many small dots of paint.

The white dots that blanket the street are the biggest ones in the whole picture. Why do you think the artist chose to make them so big?

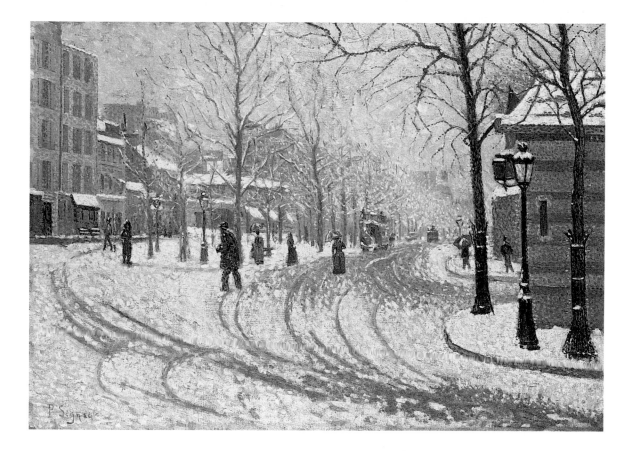

Look at the people walking along the boulevard. If the weather were warm and sunny, do you think there would be more people out and about? Maybe most of the people decided to ride the streetcar on this snowy day.

HAYSTACKS IN THE SNOW

by Claude Monet

The strange objects in this painting may look like muffins, but they're really haystacks. The artist who painted the picture liked their shape and made many pictures of them in all types of weather. The light dusting of snow on

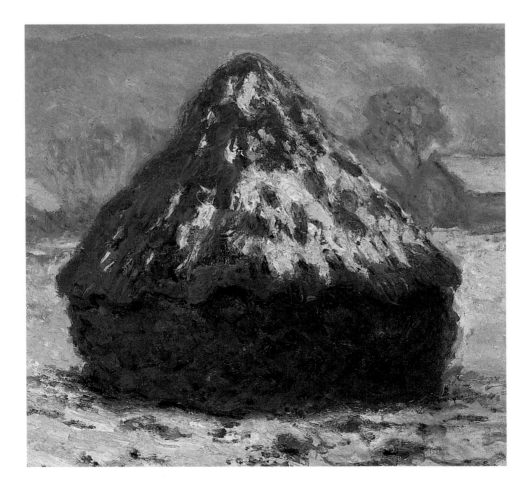

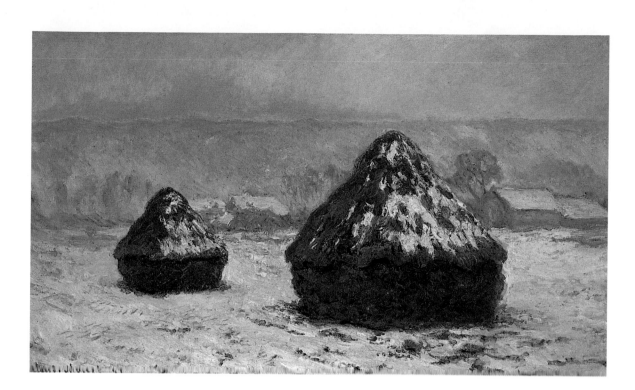

these haystacks looks like the sugary icing on a cupcake. Do you think the snow has just fallen?

Many artists use the color blue to paint snow. Why would they do such a thing, when everyone knows that snow is white? On sunny days, the snow acts like a giant mirror, reflecting the blue color of the sky. Next time you go outside on a sunny winter day, look closely—maybe you'll see blue snow, too.

THE SNOWSTORM

by Francisco José de Goya

You might start to shiver just by looking at this picture. The artist used many shades of blue to help you feel the biting cold. As you've already seen, blue, and other colors, such as green and purple, give a picture a cool feeling. The men in the center huddle together for warmth. How cold do you think it is on this snowy winter day?

26

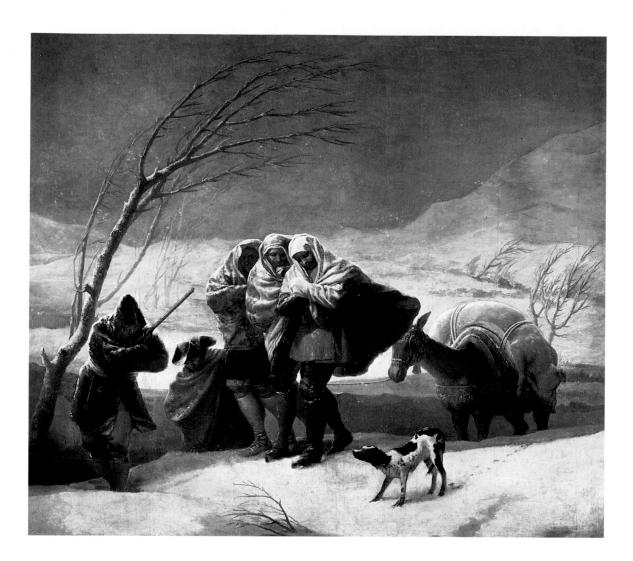

Look back at *A Gust of Wind at Ejiri*. Although they take place in different seasons, both pictures show people trying to protect themselves from the harsh weather. What other similarities can you find? If you had to travel on one of these roads, which one would you choose?

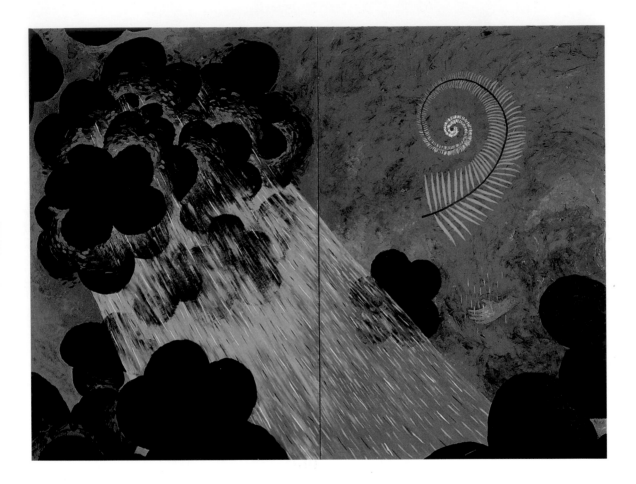

STORM

by Louisa Chase

In this picture rain pours from swollen black clouds. The column of water falls with great force, like a powerful spotlight shining down on the earth. The storm clouds look like floating black balloons. In what ways do they remind you of real clouds? In what ways are they different? Why do you think the artist painted the clouds this way?

There are some surprising elements in the picture, too, such as the green and yellow fern that floats in the air. What other unexpected object do you see? Perhaps the artist included these things to express special thoughts or feelings. What do you think they mean?

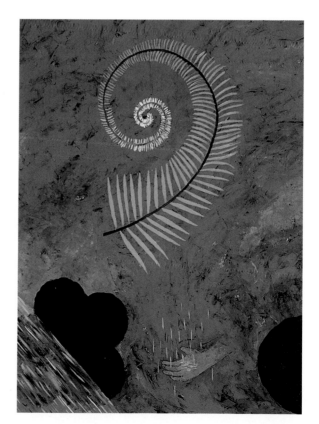

29

NIGHT OF THE EQUINOX

by Charles Burchfield

Sometimes rain can make things seem sad and gloomy. The artist who painted this picture liked to show the many moods of weather. In this painting of a dark and stormy night, the rain falls in long lines from low,

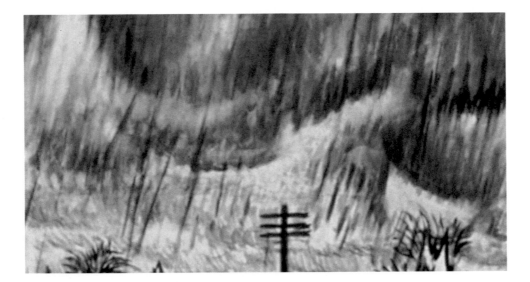

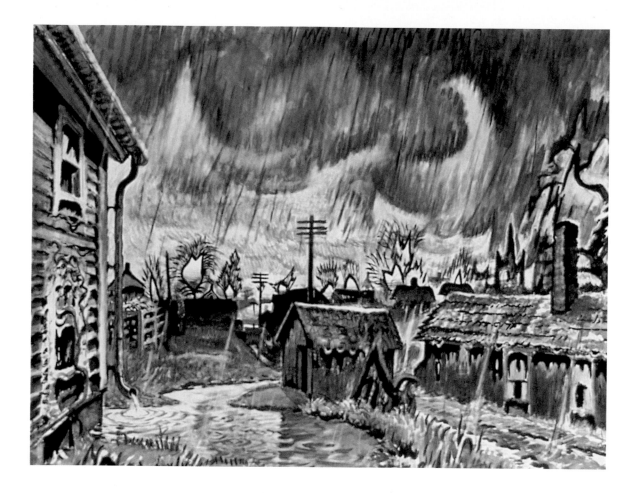

purple clouds that hang over the town. Trace your finger along the lines. Do you think this is a gentle rain, or does it hit the ground with great force? What would you do on a rainy night like this?

UMBRELLAS IN THE RAIN, VENICE

by Maurice Prendergast

Sometimes rainy days seem like kaleidoscopes of color, as in this painting of people strolling through Venice, an Italian city. Look at the blotches of color reflected in the puddles. Where is the color coming from?

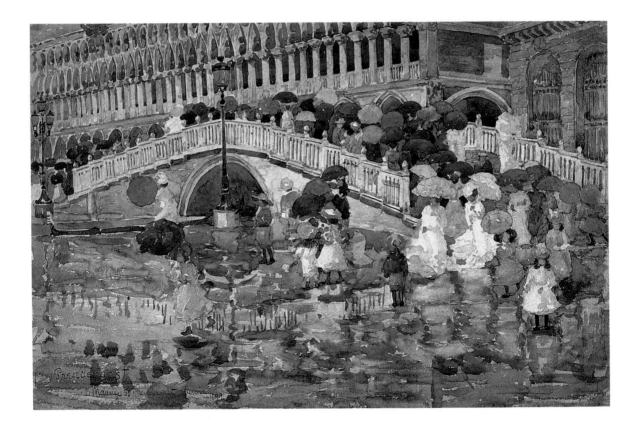

The artist used watercolor paint to capture the appearance
of a rainy day. Move your finger over the wet pavement
where the paint washes together. If you were here, per-
haps you would splash through these colorful puddles.
Who needs umbrellas, anyway?

LANDSCAPE WITH RAIN

by Wassily Kandinsky

This artist blended together many different colors to show a landscape drenched with rain. In this picture, the rain falls from a cloud in heavy, dark lines of paint. Why do you think the artist painted the rain like this? What do you think interested him more, the landscape of hills and houses or the rain?

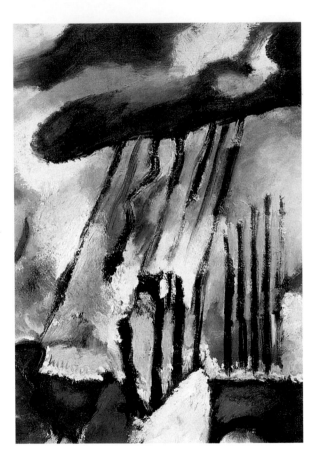

Although it's raining, the sun is beginning to break through the clouds and make the scene glow with vivid colors. You may be wondering how a day can be rainy and sunny at the same time. The artist might have wondered the same thing, and maybe that's why he painted a sun shower.

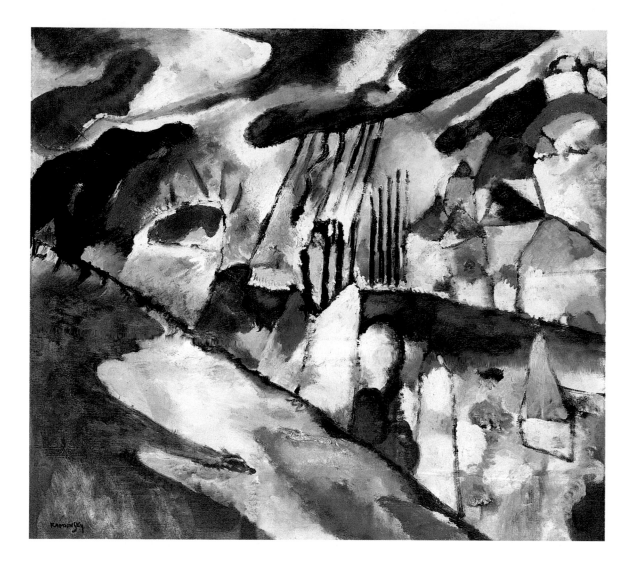

Now that you've discovered how some artists see the weather, try creating your own picture of sun, wind, rain, or snow.

NOTE TO PARENTS
AND TEACHERS

As an elementary school teacher I had the opportunity to show my students many examples of great art. I was always amazed by their enthusiastic responses to the colors, shapes, subjects, and fascinating stories of the artists' lives. It wasn't uncommon for us to spend twenty minutes looking at and talking about just one work of art. By asking challenging questions, I prompted the children to examine and think very carefully about the art, and then quite naturally they would begin to ask all sorts of interesting questions of their own. These experiences inspired me to write this book and the other volumes in the *How Artists See* series.

How Artists See is designed to teach children about the world by looking at art, and about art by looking at the world through the eyes of great artists. The books encourage children to look critically, answer—and ask—thought-provoking questions, and form an appreciation and understanding of an artist's vision. Each book is devoted to a single subject, so that children can see how different artists have approached and treated the same theme, and begin to understand the importance of individual style.

Because I believe that children learn most successfully in an atmosphere of exploration and discovery, I've included questions that encourage them to formulate ideas and responses for themselves.

And because people's reactions to art are based on their own personal aesthetic, most of the questions are open-ended and have more than one answer. If you're reading aloud to your children or students, give them ample time to look at each work and form their own opinions; it certainly is not necessary to read the whole book in one sitting. Like a good book or movie, art can be enjoyed over and over again, each time with the possibility of revealing something that wasn't seen before.

You may notice that dates and other historical information are not included in the main text. I purposely omitted this information in order to focus on the art and those aspects of the world it illustrates. For children who want to learn more about the artists whose works appear in the book, short biographies are provided at the end, along with suggestions for further reading and a list of museums where you can see additional works by each artist.

After reading *How Artists See the Weather,* children can do a wide variety of related activities to extend and reinforce all that they've learned. In addition to the simple activities I've suggested throughout the main text, they can make a paper-bag wind stocking decorated with crepe paper streamers, or plant easy-to-grow sunflower seeds in a bright part of the backyard or school grounds. Since the examples shown here are just a tiny fraction of the great works of art that feature the weather as their subject, children can go on a scavenger hunt through museums and the many wonderful art books in your local library to find more examples of weather images.

I hope that you and your children or students will enjoy reading and rereading this book and, by looking at many styles of art, discover how artists share with us their unique ways of seeing and depicting our world.

(in order of appearance)

If you'd like to know more about the artists in this book, here's some information to get you started:

VINCENT VAN GOGH (1853–1890), *pp. 4–5*

Even though this Dutch artist painted for only seven years, he left behind hundreds of paintings and drawings that are among the world's most famous and beloved artworks. Vincent van Gogh (pronounced *van-GO*) used bright colors and thick brush strokes. He liked to paint outdoors in full sunlight, and often painted two or more pictures a day. His brother Theo worked for an art dealer, and sent Vincent paints and canvas so he could spend most of his time painting. The artist's great energy can be seen in his many portraits, still lifes, and landscapes, all of which are bursting with movement and feeling. Even though people didn't appreciate van Gogh's art during his lifetime, today he is thought to be one of the greatest artists who ever lived.

ANCIENT EGYPTIAN SCULPTURE
REIGN OF AMENHOTEP IV (AKHENATEN)/18TH DYNASTY, *pp. 6–7*

Pyramids, sphinxes, and great stone temples are just some of the wonders of Ancient Egypt, a civilization that flourished for more than two thousand years and produced some of history's most amazing works of art. During the reign of one of Egypt's greatest pharaohs, Akhenaten, craftsmen from all over the land were hard at work making sculpture to adorn the king's tombs and temples. They were beginning to use exciting new materials, such as bronze and glass, in addition to the slate and limestone that had been used for centuries by earlier sculptors. Although many different types of sculpture were made during Akhenaten's seventeen years as pharaoh, the most common were carved stone reliefs showing him in happy scenes with his family or making offerings to the sun god, Aten.

ARTHUR DOVE (1880–1946), *pp. 8–9*

In 1907 Arthur Dove traveled to Paris, France, to study painting. When he returned to America, he began to show his paintings at the 291 gallery in New York City. This important gallery held exhibits of young American artists who were taking painting in bold, new directions. Arthur Dove made many paintings of nature. He especially liked to paint pictures

of the universe. He called his paintings "abstractions" because in them he changed the way things really look. This great artist was one of the pioneers of modern American painting.

EDWARD HOPPER
(1882–1967), *pp. 10–11*

Empty city streets, light-filled rooms, old houses, and brick buildings are some of the subjects that Edward Hopper painted during his long career as an artist. He painted in a realistic way, choosing to show the world as it really looks, at a time when many other artists were moving away from this style. Light was very important to Hopper. Many of his paintings show how light looks at different times of day, or how light can create moods and feelings. Because of his unique style and familiar subject matter, this painter of American life has become one of the best-known artists of the twentieth century.

ANDREW WYETH
(BORN 1917), *pp. 12–13*

Andrew Wyeth grew up around art. His father, N. C. Wyeth, was a successful illustrator and taught his son Andrew how to draw and paint. Andrew Wyeth doesn't have to look any farther than his own backyard to find subjects to paint, such

as neighbors, friends, old barns, and grassy fields. His art is realistic and full of fine details. It tells simple stories about life in the American countryside.

WINSLOW HOMER
(1836–1910), *pp. 14–15*

As a young artist Winslow Homer was a magazine illustrator. Later he began painting scenes from daily life. His first paintings were of soldiers of the American Civil War. His paintings look very real. In fact, the style he is known for is called Realism. He liked to use watercolor paints to sketch scenes from nature, especially the seaside, and he used some of these watercolor sketches as ideas for his oil paintings. Winslow Homer is one of America's most beloved artists because he was able to capture the spirit of a young and beautiful nation in his art.

KATSUSHIKA HOKUSAI
(1760–1849), *pp. 16–17*

During Katsushika Hokusai's (pronounced *cat-soo-she-kah hoe-coo-sigh*) lifetime, most Japanese artists came from wealthy families. If people were not born into wealth, they had to show enormous artistic gifts in order to study with the great teachers. Hokusai was just such a person. As a boy he worked in a book shop, and then as a wood

39

engraver's apprentice. He showed such talent that at eighteen he went to study with one of Japan's master artists. He is known for his landscape prints and paintings, especially his many pictures of Japan's Mt. Fuji.

EDOUARD MANET (1832–1883), *pp. 18–19*

Manet (pronounced *ma-NAY*) believed that artists must "be of their own time and work with what they see," and paint in new and bold ways. Many people didn't agree with him. Some of his paintings made people very angry because of just how new they looked. This French artist put his paint on in thick, free strokes of the brush that made his subjects look flat. Most people who saw his work weren't used to this new style, but a small group of painters thought it was wonderful, and learned many lessons from Manet that they used in their own paintings. These young painters came to be known as the Impressionists (look back at *Girl with a Watering Can* by Renoir), and Manet as the "father of Impressionism."

JOSEPH MALLORD WILLIAM TURNER (1775–1851), *pp. 20–21*

Swirling snowstorms, burning buildings, misty sunsets, and driving rain are some of the subjects of J. M. W. Turner's paintings. This English landscape artist was fascinated by the powerful forces of nature and tried to capture them in his work. Before Turner, most landscape artists tried to make their pictures look as real as possible. Turner's style is just the opposite. He applied paint in a loose way that made his pictures look blurry. Many people found this style quite strange at first, but later artists, such as Monet and the other Impressionists, thought it was brilliant. They learned many lessons from Turner that helped them create their own style of painting.

PAUL SIGNAC (1863–1935), *pp. 22–23*

As a member of a group of painters known as Pointillists, Paul Signac (pronounced *sin-YAHK*) made paintings composed of many tiny dots, or points, of color. As he got older, he began to enlarge those small dots into little blocks of bright paint, which have the look and feel of a mosaic or a patchwork quilt. Like the French Impressionists

40

(look back at *Haystacks in the Snow*), some of his favorite subjects were landscapes, seascapes, and other outdoor scenes.

CLAUDE MONET (1840–1926), *pp. 24–25*

After a painting called *Impression: Sunrise* by Claude Monet (pronounced *mo-NAY*) was shown in an art exhibit, he and the other artists in the show became known as Impressionists. This group of French artists made paintings that show how sunlight appears at different times of day, during different seasons of the year, and on many different kinds of objects and surfaces, such as morning light on a river or afternoon light on a stone building. Monet liked to work outdoors, and he painted with small brush strokes of pure color that came right out of the tube. He didn't mix his colors (which was the custom of the day), but let the colors blend together in the viewer's eye. Some of his most famous paintings are of waterlilies, haystacks, and the front of a great cathedral in the French town of Rouen. Monet is known as the founder of Impressionism, the style that began what is now known as modern art.

FRANCISCO JOSÉ DE GOYA (1746–1828), *pp. 26–27*

This Spanish artist is best known for pictures of kings, queens, wars, and bullfights. His paintings show people as they really look. One of his portraits of the Spanish royal family makes the group look so homely that it was a miracle he didn't lose his job as the court painter. Some of Goya's most famous works are prints that express his feelings about the world, such as the horrors of war. Many artists who lived long after Goya said his work helped them to form their own style, such as Edouard Manet (look back at *The Fife Player*).

LOUISA CHASE (BORN 1951), *pp. 28–29*

The American artist Louisa Chase once said, "Together all the elements of my paintings are what I define loosely as a sense of place." Born in Panama City, Chase first became known in the 1980s for creating landscape paintings that show how nature and weather can produce powerful feelings and moods, as well as a "sense of place." Some of her favorite subjects in this group of paintings were ocean waves, trees, storm clouds, waterfalls, and mountains, all painted with vivid colors that

represent different emotions and ideas. In the early 1990s Chase abandoned realistic subject matter and began painting in a more abstract style. Louisa Chase lives and works in New York City.

CHARLES BURCHFIELD (1893–1967), *pp. 30–31*

"There is nothing in nature that will ever fail to interest me." The artist who spoke these words was Charles Burchfield, an American watercolor painter who loved the outdoors and the natural world. Many of his paintings show the sides of nature that most people would rather not have to deal with, such as rain- and snowstorms. To Charles Burchfield, everything that happened in nature was a source of wonder, and he tried to capture this feeling in his paintings. Some of his favorite subjects were changing seasons, starry nights, and landscapes filled with blowing grasses and flowers in bloom.

MAURICE PRENDERGAST (1859–1924), *pp. 32–33*

Maurice Prendergast was born in Canada, but lived and worked in America. In the early twentieth century he was part of a group of artists known as The Eight. These eight painters believed that artists should paint exactly what they choose to, instead of following the popular styles of the day. They also were known as the Ashcan School because many of their paintings captured the grimy, dark side of city life. Prendergast stood out from the group because his paintings were full of bright patches of color that seemed to glow and move, much like the French Impressionists, whose work he admired (look back at *Haystacks in the Snow* and *Boulevard de Clichy*). Today Maurice Prendergast is known as an American Impressionist.

WASSILY KANDINSKY (1866–1944), *pp. 34–35*

This Russian-born painter is one of the most important artists of the twentieth century. Why is he so important? Before his time, artists made pictures and sculptures of things that people could recognize, such as vases of flowers or beautiful landscapes. Wassily Kandinsky decided to make abstract paintings instead. An abstract work of art does not show people, places, or things, but shapes, lines, and colors. This was a whole new approach to art. The leader of a group of artists called the Blue Rider, he believed that bold colors and forms could express feelings. Kandinsky's work inspired many artists to create their own styles of abstract art.

SUGGESTIONS FOR FURTHER READING

The following children's titles are excellent sources for learning more about the artists presented in this book:

FOR EARLY READERS (AGES 4–7)

Anholt, Laurence. *Camille and the Sunflowers: A Story About Vincent van Gogh.* Hauppauge, New York: Barron's Educational Series, 1994.
Camille Roulin, the young boy whose family befriended van Gogh, describes his experiences with the great Dutch artist while he lived and painted in Arles, France.

Bjork, Christina. *Linnea in Monet's Garden.* New York: R&S Books, 1987.
A little girl named Linnea visits Claude Monet's garden in the French town of Giverny and learns about his life and art along the way. This title is also available on videotape.

FOR INTERMEDIATE READERS (AGES 8–10)

Dubelaar, Thea, and Ruud Bruijn. *Looking for Vincent.* New York: Checkerboard Press, 1992.
A boy and his eccentric aunt set out to purchase a painting by Vincent van Gogh, and in the process learn about the artist's extraordinary life.

Mason, Antony. *Monet: An Introduction to the Artist's Life and Work.* Famous Artists series. Hauppauge, New York: Barron's, 1995.
This wonderful book provides a wealth of information about the French Impressionist painter.

Paint and Painting. Voyages of Discovery series. Scholastic Inc., New York. 1994.
The history and techniques of painting are described in this beautifully designed, interactive book.

FOR ADVANCED READERS (AGES 11+)

Beneduce, Ann Keay. *A Weekend with Winslow Homer.* New York: Rizzoli, 1993.
This informative and clever book takes you back in time to meet the American painter. Another title in the series is *A Weekend with van Gogh* by Rosabianca Skira-Venturi.

Mühlberger, Richard. *What Makes a Monet a Monet.* New York: The Metropolitan Museum of Art and Viking, 1994.
The work of the French painter is explored in a way that teaches children how to recognize his unique style. Another title in the series is *What Makes a van Gogh a van Gogh,* also by Richard Mühlberger.

ANCIENT EGYPTIAN SCULPTURE

- Ägyptisches Museum, Berlin
- Archaeological Museum, Cairo
- The Brooklyn Museum, New York
- The John Paul Getty Museum, Malibu, Calif.
- The Metropolitan Museum of Art, New York
- Museum of Fine Arts, Boston

CHARLES BURCHFIELD

- The Burchfield-Penney Art Center, Buffalo State College
- Butler Institute of American Art, Youngstown, Ohio
- Charles H. MacNider Museum, Mason City, Iowa
- Miami University Art Museum, Oxford, Florida
- Midwest Museum of American Art, Elkhart, Indiana
- Minnesota Museum of Art, Saint Paul
- National Museum of American Art, Smithsonian Institution, Washington, D.C.
- Westmoreland Museum of Art, Greensburg, Pennsylvania

LOUISA CHASE

- Aldrich Museum of Contemporary Art, Ridgefield, Connecticut
- Denver Art Museum
- Indianapolis Museum of Art, Indiana
- Jacksonville Art Museum, Florida
- Museum of Modern Art, New York

ARTHUR DOVE

- Amon Carter Museum, Fort Worth
- New Jersey Museum, Trenton
- The Phillips Collection, Washington, D.C.
- Carl Van Vechten Gallery of Fine Arts, Fisk University, Nashville
- Wichita Art Museum, Kansas

FRANCISCO JOSÉ DE GOYA

- Kimbell Art Museum, Fort Worth
- Meadows Museum at Southern Methodist University, Dallas, Texas
- The Metropolitan Museum of Art, New York
- Prado, Madrid
- Norton Simon Museum of Art, Pasadena, California
- University of Kentucky Art Museum, Lexington

KATSUSHIKA HOKUSAI

- The Art Institute of Chicago
- Bibliothèque Nationale, Paris
- British Museum, London
- Freer Art Gallery, Smithsonian Institution, Washington, D.C.
- Los Angeles County Museum of Art
- The Metropolitan Museum of Art, New York
- Museum of Fine Arts, Boston
- Tokyo National Museum

WINSLOW HOMER

- Addison Gallery of American Art, Phillips Academy, Andover, Massachusetts
- Amon Carter Museum, Fort Worth
- Arizona State University Art Museum, Tempe
- Brandywine River Museum, Chadds Ford, Pennsylvania
- Freer Gallery of Art, Smithsonian Institution, Washington, D.C.
- National Museum of American Art, Smithsonian Institution, Washington, D.C.
- North Carolina Museum of Art, Raleigh
- Pennsylvania Academy of the Fine Arts, Philadelphia
- Portland Museum of Art, Maine
- Wichita Art Museum, Kansas

EDWARD HOPPER

- Addison Gallery of American Art, Phillips Academy, Andover, Massachusetts
- Delaware Art Museum, Wilmington
- Hopper House/Edward Hopper Preservation Foundation, Nyack, New York
- The Huntington Library Art Collections and Botanical Gardens, San Marino, California
- The Montclair Art Museum, New Jersey
- Portland Museum of Art, Maine
- University of Arizona Museum of Fine Art, Tucson
- Yale University Art Gallery, New Haven, Connecticut

WASSILY KANDINSKY

- The Art Institute of Chicago
- Solomon R. Guggenheim Museum, New York
- Museum of Modern Art, New York
- Munson-Williams-Proctor Institute Museum of Art, Utica, New York

EDOUARD MANET

- The Art Institute of Chicago
- Courtauld Institute Galleries, London
- Charles and Emma Frye Art Museum, Seattle, Washington
- Heckscher Museum, Huntington, New York
- The Metropolitan Museum of Art, New York
- Musée d'Orsay, Paris
- Norton Simon Museum of Art, Pasadena, California

CLAUDE MONET

- Birmingham Museum of Fine Art, Alabama
- Dallas Museum of Art
- Dixon Gallery and Gardens, Memphis
- High Museum of Art, Atlanta
- The Metropolitan Museum of Art, New York
- Musée d'Orsay, Paris
- Museum of Fine Arts, Springfield, Massachusetts
- Museum of Fine Arts, St. Petersburg, Florida
- Museum of Modern Art, New York
- North Carolina Museum of Art, Raleigh
- Philadelphia Museum of Art
- Shelburne Museum, Vermont

- Spencer Museum of Art at the University of Kansas, Lawrence
- Tate Gallery, London
- University of Rochester Memorial Art Gallery, Rochester, New York

MAURICE PRENDERGAST

- Cape Ann Historical Association, Gloucester, Massachusetts
- William A. Farnsworth Library and Art Museum, Rockland, Maine
- Maier Museum of Art, Randolph-Macon Women's College, Lynchburg, Virginia
- Mattatuck Museum, Waterbury, Connecticut
- Munson-Williams-Proctor Institute Museum of Art, Utica, New York
- Museum of Fine Arts, Boston
- Reynolda House Museum of American Art, Winston-Salem, North Carolina
- Terra Museum of American Art, Chicago

PAUL SIGNAC

- The Brooklyn Museum, New York
- Minneapolis Museum of Art
- Musée d'Orsay, Paris
- Museum of Modern Art, New York
- National Museum of Modern Art, Paris

JAMES MALLORD WILLIAM TURNER

- Allen Memorial Art Museum, Oberlin College, Oberlin, Ohio
- Cleveland Museum of Art
- Dallas Museum of Art
- The Huntington Library Art Collections and Botanical Gardens, San Marino, California
- Indianapolis Museum of Art
- Museum of Fine Arts, Boston
- Taft Museum, Cincinnati
- Tate Gallery, London
- The Turner Museum, Denver
- University Center Gallery at Bucknell University, Lewisburg, Pennsylvania

VINCENT VAN GOGH

- The Art Institute of Chicago
- E. G. Bührle Collection, Zurich
- The John Paul Getty Museum, Santa Monica, California
- Solomon R. Guggenheim Museum, New York
- The Metropolitan Museum of Art, New York
- Museum of Modern Art, New York
- National Gallery of Art, Washington, D.C.
- National Museum Vincent van Gogh, Amsterdam
- Rijksmuseum Kröller-Müller, Otterlo, Netherlands
- Saint Louis Art Museum
- Norton Simon Museum of Art, Pasadena, California

ANDREW WYETH

- Brandywine River Museum, Chadds Ford, Pennsylvania
- Delaware Art Museum, Wilmington
- William A. Farnsworth Library and Art Museum, Rockland, Maine
- Mead Art Museum, Amherst College, Amherst, Massachusetts
- Portland Museum of Art, Maine
- Orono Museum of Art, University of Maine, Orono, Maine

Vincent van Gogh (1853–1890). *The Sower,* 1888. Oil on canvas, 25¼ × 31¾ in. (64 × 80.5 cm), Rijksmuseum Kröller-Müller, Otterlo, Netherlands. Photograph courtesy of Art Resource, New York. Vincent van Gogh (1853–1890). *The Sower,* 1888. Oil on burlap on canvas, 28⅞ × 36¼ in. (73.5 × 92 cm), E. G. Bührle Collection, Zurich. A.K.G., Berlin/Superstock. *Royal Family of Amenophis IV Akhenaten Offers a Sacrifice to Aten, the Sun God,* 1350 B.C. Limestone, 41⅜ × 19⅝ in. (105 × 50 cm), Archaeological Museum, Cairo, Egypt. Erich Lessing/Art Resource, New York. Arthur Dove (1880–1946). *Sun Drawing Water,* 1933. Oil on canvas, 24⅜ × 33⅝ in. (61.9 × 85.4 cm), The Phillips Collection, Washington, D.C. Edward Hopper (1882–1967). *Rooms by the Sea,* 1951. Oil on canvas, 29 × 40⅛ in. (73.7 × 101.9 cm), Yale University Art Gallery, New Haven, Conn. Bequest of Stephen Carlton Clark, B.A., 1903. Andrew Wyeth (b. 1917). *Wind From the Sea,* 1947. Tempera on canvas, 18½ × 27½ in. (47 × 69.9 cm), Mead Art Museum, Amherst College, Amherst, Mass. Gift of Charles and Janet Morgan. Winslow Homer (1836–1910). *The West Wind,* 1891. Oil on canvas, 30 × 44 in. (76.2 × 111.8 cm), Addison Gallery of American Art, Phillips Academy, Andover, Mass. Gift of anonymous donor. © Addison Gallery of American Art. All Rights Reserved. Katsushika Hokusai (1760–1849). *A Gust of Wind in Ejiri, in the Province of Suruga,* 1831–33. Woodblock print, 9½ × 14¾ in. (24.1 × 37.5 cm), The Metropolitan Museum of Art, Rogers Fund, 1936. Edouard Manet (1832–1883). *Departure from Boulogne Harbor,* 1864/65. Oil on canvas, 29 × 36½ in. (73.6 × 92.6 cm), The Art Institute of Chicago. Photograph © 1994, The Art Institute of Chicago. All Rights Reserved.

J.M.W. Turner (1775–1851). *Snowstorm—Steamboat Off a Harbor's Mouth,* 1842. Oil on canvas, 36 × 48 in. (91 × 122 cm), Tate Gallery, London. Photograph courtesy of Art Resource, New York. Paul Signac (1863–1935). *Boulevard de Clichy,* 1886. Oil on canvas, 18¼ × 25¾ in. (46.5 × 65.6 cm), The Minneapolis Institute of Arts; Bequest of Putnam Dana McMillan. Claude Monet (1840–1926). *Haystacks in the Snow,* 1891. Oil on canvas., 23 × 39 in. (58.4 × 99.1 cm), Shelburne Museum, Shelburne, Vermont. Photograph by Ken Burris. Francisco José de Goya (1746–1828). *The Snowstorm,* 1786. Oil on canvas, 108⅜ × 115⅛ in. (275 × 293 cm), Museo del Prado, Madrid. Scala/Art Resource, New York. Louisa Chase (born 1951). *Storm,* 1981. Oil on canvas, 90 × 120 in. (229 × 305 cm), Denver Art Museum. (Purchased with funds from the National Endowment for the Arts Matching Fund and Alliance for Contemporary Art.) Charles E. Burchfield (1893–1967). *Night of the Equinox,* 1917–55. Watercolor, brush and ink, gouache, and charcoal on paper, 40⅛ × 52⅛ in. (100.9 × 132.4 cm), National Museum of American Art, Smithsonian Institution, Washington, D.C. Photograph courtesy of Art Resource, New York. Maurice Prendergast (1858–1924). *Umbrellas in the Rain, Venice,* 1899. Watercolor and graphite on paper. 14 × 20⅞ in. (35.6 × 53 cm), Museum of Fine Arts, Boston. Charles Henry Hayden Fund. Wassily Kandinsky (1866–1944). *Landscape with Rain (Landschaft mit Regen),* January 1913. Oil on canvas, 27⅝ × 30¾ in. (70.2 × 78.1 cm), Solomon R. Guggenheim Museum, New York. Photograph by David Heald. © The Solomon R. Guggenheim Foundation, New York.